# STUDENT BEHAVIOR IN ART CLASSROOMS

## THE DYNAMICS OF DISCIPLINE

Frank D. Susi
Kent State University

## ABOUT NAEA

Founded in 1947, the National Art Education Association is the largest professional art education association in the world. Membership includes elementary and secondary teachers, art administrators, museum educators, arts council staff, and university professors from throughout the United States and 66 foreign countries. NAEA's mission is to advance art education through professional development, service, advancement of knowledge, and leadership.

## ABOUT THE AUTHOR

Dr. Frank Susi is Professor of Art and Coordinator of Art Education at Kent State University, Kent, Ohio.

ISBN 0-937652-75-X

***Acknowledgments***
*I am grateful to Cindy Henry and Linda McFeteridge for their suggestions and editorial advice. The comments and ideas offered by Richard Kindsvatter were most helpful.*

# CONTENTS

# CONTENTS *(continued)*

*Foreword*

As an aspect of the educational world, classroom discipline is a hardy and tenacious problem that won't go away. Recent polls and surveys have shown that managing student behavior maintains a pre-eminent position in the daily life of teachers. Novices and veterans alike experience the frustration of having to deal with disobedient, rude, and disrespectful students. Most art teachers would rather teach than have to deal with misbehaving students who distract attention and eat up class time. A variety of approaches have been developed to help with these problems. Video tape programs, books, journal articles, and other publications are available to offer ideas and encouragement to the harried teacher. This NAEA handbook can help, too. While not offering a panacea, it does present information and a perspective that can serve as a reference for individual teachers as well as offering a source for dialogue on policy formation and personal development. Many of the ideas presented here will be familiar to experienced teachers. Some of the points will offer new perspectives into the nature and complexity of discipline problems as well as offering suggestions for the development of management practices that prevent them from happening in the first place. Suggestions for how incidents of misbehavior can be dealt with in humane and professional ways are also presented. To be most useful, the approaches discussed here should be considered with a questioning attitude and slight dose of skepticism. Every teacher must reflect upon his or her personal goals for a quiet and orderly classroom. Fostering self control within students should head the list. Standards for personal conduct that are imposed and enforced by the art teacher may last only as long as students are in the classroom. In the longer view, we must consider our responsibilities to the larger society for how students behave when they leave school. Discussing the concepts offered here with colleagues may prove helpful in gaining a perspective on how these concepts can be applied in specific situations. The interested teacher is encouraged to consider the suggestions that make sense and pursue the references as sources of further information.

## Part 1
## UNDERSTANDING DISCIPLINE IN ART CLASSROOMS

For many art teachers, controlling student behavior in their classroom is the most aggravating and challenging problem they must face on a regular basis. When disorder reigns, efforts to establish order and control take precedence over delivery of the academic program. Even a few disorderly students can disrupt the education of those who are in school to learn. More than a few disorderly students can make education impossible. All students have the right to an education, and teachers must recognize the obligation to protect that right (Bauer, 1985).

In 1988, the U.S. Supreme Court ruled that public schools cannot remove disruptive children for more than 10 days without the permission of their parents or by court order. Thus, what was once known as *mainstreaming* has shifted to what is now called *inclusion*. According to this mandate, excluding any child from a regular classroom, regardless of how disruptive he or she might be, cannot be justified (Barker, 1994).

A myriad of social and environmental factors interact to influence how students behave in any classroom. These include the influence of mass-market media, home life circumstances, dietary and nutrition practices, hygiene and personal health conditions, psychological problems, peer relations, and the values associated with the diverse ethnic groups and cultural orientations represented in our society. Problems associated with poverty, discrimination, and shifting societal values further exacerbate the problems.

The 26th annual Gallup poll of the public's attitudes toward the public schools reported that, for the first time ever, the category of "fighting, violence, and gangs" shares the number one position with "lack of discipline" as the biggest problem facing local public schools. While the uproar about violence is in part media phenomenon, seventy percent of respondents to the poll indicated the increased use of drugs and alcohol, the growth of youth gangs, the availability of weapons, and a general breakdown in the American family as the main causes of the problems in schools. Between 1969 and 1985, lack of discipline was the most frequently mentioned problem each year except 1971. From 1986 to 1991, drug abuse by students was most frequently mentioned, with lack of discipline ranking second (Elam, Rose, and Gallup, 1994).

Veteran teachers recall that 30-plus years ago, when a child created a problem in school, the child's parents could be counted on to follow through with corrective measures at home. Adults supported each other's authority and, in the process, communicated a fairly uniform set of standards to children concerning expectations for their behavior. These same teachers say that parents of today, upon hearing that their child misbehaved at school, are likely to challenge the teacher's judgment and attempt to defend or rationalize the youngster's actions. Thus, parents and teachers have become divided while children escape accountability for their behavior.

### Sources of Discipline Problems

Success as a teacher requires an awareness of the many factors that influence how students behave. For example, many of the values and practices associated with the urban "street" culture have now become a part of life in suburban and rural communi-

ties. The presence of this cultural migration and the behaviors and values associated with it are evident even in non-urban classrooms.

In a discussion of the inclination toward interpersonal aggression and violence often observed in ghetto youngsters, Anderson (1994) describes two orientations to behavior: "decent" values that reflect middle class standards, and the oppositional "street" culture, whose norms for personal conduct often run counter to mainstream society. The code of the streets amounts to a set of informal rules that govern how individuals act in certain circumstances.

At the core of the code is the issue of respect—being treated with the deference one believes he or she deserves. In the "street" culture, especially among young people, respect is hard won but easily lost and so must be constantly guarded. A person's appearance, including his or her clothing, general demeanor, and way of moving, is designed to deter transgressors while affording respect to that individual. If respected, one can avoid being bothered in public. If disrespected ("dissed"), an individual may sense impending physical danger. For example, sustaining eye contact for too long may be an indication of another person's negative intentions. The person able to "take care of himself" or herself is accorded a certain deference, which translates into a sense of physical and psychological control and personal well being. Thus, an individual's facial expression, gait, and verbal manner must send a nonverbal message of deterrence that says, "I am able to defend myself; don't try to test me." Problems associated with low self-esteem tend to make youngsters highly sensitive to perceived slights and to being "dissed."

In the homes of "street" youngsters, the adults can be quite aggressive, yelling at and striking them for small infractions of rules. From this, children learn that to solve any kind of interpersonal problem, they must resort to hitting and other forms of violent behavior.

By the time they are teenagers, most urban youth have either internalized the code of the streets or at least have learned how to comport themselves in accord with its rules. Whereas youngsters of the two orientations often coexist in the same neighborhoods and schools, youngsters with "decent" orientations sometimes have to act "street" to protect themselves.

Many less alienated young Blacks have assumed a street-oriented demeanor in school as a way of expressing their blackness even though they may actually embrace more moderate values. These individuals are trying to be part of the mainstream culture, but the racism they encounter, real and perceived, helps legitimize the oppositional culture, and so, on occasion their actions reflect street behavior.

### Defining Discipline

Mention the word *discipline* and most teachers think of a negative situation and the circumstances associated with misbehavior by students. But positive behaviors and the conditions in which the actions of students are consistent with the teacher's expectations are also an aspect of discipline. Therefore, efforts to establish a productive and supportive psychological environment in the classroom are as much a part of discipline as the monitoring and intervention necessary for maintaining order. In the broad-

est sense, *discipline* refers to the approaches used to organize and manage classrooms in ways that prevent misbehavior and optimize the conditions for learning as well as those practices associated with use of the teacher's power and authority to address problems when they occur.

The term *management* implies an orderly setting where the teacher directs student activity. While suggesting a teacher-oriented classroom, a well managed situation can be one which is student centered (Randolph & Evertson, 1994).

### The Goals of Misbehavior

After observing hundreds of misbehaving children, Rudolf Dreikurs (Dreikurs and Cassell, 1972) identified four goals or purposes for misbehavior: attention getting, power, revenge and display of inadequacy. Dreikurs explains these concepts as follows:

*Attention Getting.* This behavior occurs when youngsters are unable to gain status through useful contributions. Such individuals believe that only when others pay attention to them do they have a place in the world. Attention seeking behaviors span a range from innocuous (making smart remarks, showing helplessness) to annoying (being obnoxious, showing-off, clowning). To these individuals, being ignored is intolerable. They will accept humiliation, punishment, or pain to get attention. In Dreikurs' view, such children are discouraged. Teachers should help them make useful contributions and give them attention only when they are not demanding it. He believes the 38 for all misbehavior is encouragement, but not praise. Encouragement is given to inspire and assist the child to behave in ways that are constructive and positive. Praise tends to give personal attention that may further encourage negative actions.

*Power.* The goal of power is sought by youngsters who want to be boss. In many ways, the goal of power is similar to attention getting, but at a more intense level. These individuals tend to argue, contradict, lie, and refuse to do assigned work. They are often openly disobedient or recalcitrant. Although they have the ability to do the work, they will do it only on their own terms. The teacher's initial reaction to children seeking power is to feel threatened by the challenge to his or her leadership. But efforts to control the power-seeking child are usually futile. If the teacher is successful one day, the child may become even more rebellious the next. For the teacher, no final victory is possible. The longer a struggle continues, the more such children become convinced that power has value, and the more their resolve is strengthened.

To address the problems associated with power-seeking behaviors, Dreikurs suggests that the teacher avoid any sort of competition with the student and avoid conflict related to this power seeking. Teachers must learn to recognize that power-seeking youngsters are ambitious and must try to redirect them to useful channels. For example, power seeking students can be given a position of responsibility that they believe has prestige. Of course, guidance must be given so the position won't be abused. An

appeal to this type of child for advice and assistance will be more effective than threats or reprisals. The use of contracts, special awards or recognitions, assignment options, and personalized projects removes the teacher from the power struggle. Power-seeking youngsters must be respected for an ability to upset school authorities.

*Revenge.* Retaliation is sought by the youngsters who feel beaten down. These individuals tend to be so discouraged that they believe that they can find their place only by hurting others. Revenge-minded students complain, argue, say the teacher is unfair, and generally disrupt the work of others. Their actions are often vicious or violent, and sometimes brutal. They are sore losers and, when defeated, begin immediately to plot revenge. Such youngsters are difficult to deal with and may require the services of a mental health professional.

Teachers can help power-seeking students by encouraging them to express feelings in positive ways such as scheduling appointments for making complaints, using a suggestion box, organizing a class council, and drawing names or numbers from a hat when selections must be made. The primary aim of the teacher should be to try to win such children over and to persuade them that they can be liked by others. Punishment will produce only more rebellion and should be avoided.

*Displays of Inadequacy.* Helplessness behaviors occur when youngsters are deeply discouraged, give up all hope, and expect only failure and defeat. These individuals tend to feel hopeless or may assume this position to avoid situations where they might be embarrassed or humiliated. Some destroy their work, do not complete it, or do not turn it in. Displays of inferiority allow them to avoid test situations where losing is possible. These students rarely participate in activities and, by displays of extreme ineptitude, prevent anything being demanded or expected of them.

According to Dreikurs, teachers tend to give up on such a youngster, falling for the child's provocation and thus leaving the child alone. Great amounts of encouragement are needed, especially when a discouraged child makes a mistake. The teacher can best help by displaying a sincere conviction that there is hope for the child and that the teacher will not give up. In some cases, a student displaying these characteristics has set unrealistic goals and needs direction in setting expectations where he or she can be successful. Short assignments in a favorite media, providing alternative ways to complete an assignment, and graphically showing success help build confidence.

By adolescence, most youngsters have learned how to disguise the behaviors associated with displays of inadequacy so many of the signs and patterns described above are not apparent in day-to-day contacts. This sublimation occurs as young teens become interested in music, sex, and other diversions.

Many teachers willingly assume responsibility for dealing with students who experience persistent patterns of misbehavior in their classroom. In studies of effective teachers, those rated as effective made some attempt to deal with problems personally, whereas teachers rated ineffective often disclaimed responsibility or competence for dealing with problems or attempted to refer them to a principal or counselor. Effective

teachers often involve other professionals as part of their attempt to deal with problems, stayed personally involved and do not try to turn them over to others (Brophy, 1982).

### *Discipline in the Art Classroom*

Adding to the challenge of understanding student behavior for art teachers are the many dimensions of study associated with the content of art education. Art classrooms are complex academic settings with curricula that feature both self expression and response to works of art created by others. The activities and behaviors associated with those domains can range from the physical (sculpting in plaster, pulling an edition of prints, hand building a pot) to the intellectual (arranging images on a computer screen, writing a critique, studying a series of slides). The involvement associated with inquiry in art history, aesthetics, studio production, and art criticism requires that art teachers must manage the behaviors of students in a wide ranging, multi-faceted classroom that features a variety of formally and informally organized learning activities. This is a tall order for even the most knowledgeable, skilled, and experienced instructors.

Yet art education lacks the models for classroom management that match the study and work behaviors associated with other disciplines. Most research in the area of discipline looks at classrooms where academic tasks are routine and predictable. Little research into the different instructional circumstances and the kinds of management decisions and teacher actions required to create a supportive learning environment in art classrooms has been conducted. As the field shifts to include multiple approaches to study in various art disciplines, art teachers must develop a broad-based understanding of the relationship between instructional practices and realistic expectations for student behavior (Randolph and Evertson, 1994).

### *The Need to Manage Student Behavior*

Aside from the need to maintain an orderly and safe learning environment, teachers must devise management practices that are designed to guide student learning while helping students acquire the social and behavioral skills necessary for becoming effective, productive, and law abiding citizens in the larger society. McLaughlin (1994) describes two orientations to managing student behavior. Each has different aims and potential outcomes:

1. The responsibility perspective emphasizes approaches that encourage self control and the development of a sense of personal accountability that comes from standards and values lying within the individual. In this view, students learn how to behave by being treated with dignity and respect.

2. The obedience perspective features setting rules and maintaining adult control over young people. In this view, teachers are concerned with the most expedient means of control available. Students are expected to learn what the teacher

teaches, and everyone is treated the same, no matter what. Rewards and punishments are assigned as appropriate.

Each view has characteristics that define its educational advantages and limitations. Teachers should analyze each to become familiar with the attributes of the approach most consistent with their values and priorities (Curwin and Mendler, 1988).

### Conclusion

This chapter has provided a basis for understanding why students misbehave and the need for an orderly learning environment. Before addressing ideas that can be considered for preventing discipline problems and for dealing with misbehavior when it occurs, a series of assumptions about teaching and the teacher's responsibilities as a classroom manager must be considered:

1. Teachers are expected to be both the instructional leaders and the final authorities on what happens in their classrooms. Although students may sometimes be invited to share in decision making about what, when, and how to learn, the teacher retains the ultimate responsibility for managing all aspects of the learning environment (Brophy, 1983).

2. Facilitating learning and preventing misbehavior should be major considerations when planning any art lesson. Effective discipline can be described as an outcome that results from an artful combination of instructional and interpersonal practices which serve to focus student attention on positive and productive educational activities.

3. When a discipline problem occurs, teachers must first look at their own personal behaviors, instructional practices, and management systems for clues leading to the sources of that problem. Through a process of reflection and self study, teachers must determine if everything possible has been done to make the lesson so challenging, interesting, and relevant that inappropriate behavior would be unattractive. All factors within the instructional environment must be evaluated as potential contributors. Only when all elements under the direct control of the teacher have been eliminated as potential causes of the problem should teachers look to outside factors and the offending student for clues which may help solve the problem.

4. Simplistic, fool-proof solutions to the complex issue of managing student behavior do not exist. Many teachers say they have obtained effective levels of classroom control through trial-and-error experimentation. This process involved testing methods that seemed suitable for a given lesson or group of students in an attempt to discover what would work. By building on successful techniques, teachers have adopted and refined effective approaches by adapting them to different situations. This eclectic view assumes that whatever works for managing behavior is acceptable.

In fact, discipline problems tend to have multiple levels of complexity and are often triggered by a variety of circumstances. For example, certain personal characteristics (e.g., poorly developed social skills or work habits) may make some students more likely to misbehave than others. While an eclectic approach might be effective in some cases, care must be taken to assure that the action taken to control misbehavior is based on an informed and educationally sound belief system. A patchwork approach that relies on a series of unconnected measures and that is implemented as a series of unconnected measures may send mixed messages that interfere with the development of reasoned behavior norms (Gotfredson, 1992).

Balancing compassion, logic, and common sense is a challenge every art teacher must accept. As we consider the aspects of practice that can be manipulated to prevent inappropriate behavior while promoting student learning, a series of questions can guide our inquiry:

1. Given the myriad of activities that occur in art classrooms, what guidelines can be used to make decisions about expectations for student behavior?

2. In what ways can student involvement be used to help teachers establish norms and standards for behavior in art classrooms?

3. How can we make certain that management-related practices support learning while advancing the social development of students?

4. How are norms, rules, and expectations best communicated to students and reinforced over time?

5. How can reflection be developed as a skill that can be used to identify, analyze, and improve management practices?

The next section will continue with an examination of strategies that aim to (a) prevent discipline problems and (b) confront them with knowledge, skill, and compassion when they do occur.

**Part 2**
# PREVENTING DISCIPLINE PROBLEMS

## SETTING THE STAGE FOR LEARNING

Many educators believe that the combination of a well planned lesson and sound instructional strategies provide the best approach for preventing discipline problems. In this view, the student's attention is focused on interesting and absorbing academic activity and he or she has little inclination or opportunity to misbehave. Good behavior is assumed to be a natural outcome of effective teaching.

The research on effective teaching shows that long before students arrive to start the school year successful teachers begin to organize and plan how time, space, and resources will be used. According to Evertson and Emmer (1982), the first days and weeks of the school year are crucial to a teacher's management system. During that period, students first come into contact with the standards and expectations for their behavior. For most students, the novelty of the situation—new teacher and setting, different procedures, new classmates—makes them receptive to new modes of behavior. During this "get acquainted" period, teachers establish their role as instructional leader while presenting guidelines and reinforcing appropriate conduct.

By setting clear expectations and rules and by establishing consequences for misbehavior at the beginning of the year, teachers lend form and structure to the disciplinary system they will use throughout the year while reducing the ambiguity and uncertainty of the new setting. These measures help make the classroom an environment that students understand. When students establish patterns of inappropriate behavior early in the school year and those behaviors are practiced and reinforced over time, changing them means that the undesirable behaviors must first be extinguished. This can be a stressful and difficult task.

Planning for the first days of school should be based on two interconnected goals: (a) the teacher's need to implement a planned program for management and (b) the students' need for information about the teacher's expectations. Evertson and Emmer (1982) offer a series of suggestions for beginning the school year:

1. Take time to present and discuss rules. Because rules provide a framework for expected behavior, applying them effectively depends on the students' ability to understand and practice relevant behaviors. During the first weeks of school, the teacher can explain how rules will be interpreted and point out instances of desirable behaviors and the rules which refer to them.

2. Teach classroom procedures as carefully as any other learning objective. This includes explaining and demonstrating desired behaviors, providing opportunities for students to practice specific skills, and providing corrective feedback.

3. Teach specific procedures as they are needed by students. For example, routines for entering the room and storing books, getting seated, obtaining supplies and using sinks should be taught at or near times when those routines will be prac-

ticed or the items used. In some cases, however, detailed information can be given in advance of when it will be used. For instance, the steps involved in cleaning and storing a paint brush can be explained as part of a demonstration. Whatever the circumstances, procedures should be carefully taught and applications monitored, critiqued, and reinforced.

4. Involve students in tasks that promote a high rate of access during the first days and weeks to promote a positive and success-oriented outlook. If assignments are too difficult or complex, the teacher's time and attention will likely be directed to helping solve problems experienced by individual students and away from the important job of monitoring the entire class.

5. Plan and present activities that feature a whole-group focus. By presenting information and directions to everyone at the same time and by giving the entire group the same assignment, monitoring behavior is easier and procedures are simpler than when individual or small group instruction is provided. After having learned appropriate behaviors and having demonstrated their ability to follow general directions, students will be ready for more complex assignments. Through this approach, the teacher can also gain an awareness of students who need special help or close supervision.

6. Students may not know how to perform after one trial. Complex procedures should be reviewed several times, perhaps using different instructional approaches, to verify understanding.

In a study to determine the attitudes and preferences of secondary students during the first days of school, Guay (1993) described the largest group of respondents as wanting information about how the class would be run, including homework assignment policies, class rules and enforcement, and privileges that would be available to them. The next largest group wanted teachers to show they liked students and generally had a positive attitude toward teaching.

### Monitoring

Monitoring is a skill that can be learned and practiced as an early warning system for detecting minor problems before they become major disturbances. Monitoring means watching the behavior of all students and keeping track of their progress on tasks and assignments. By carefully observing attending behaviors (eyes directed where they should be, materials being used in appropriate ways); by noting adherence to rules and procedures; and by looking for indications of confusion, frustration, or unusually slow progress, the alert teacher can respond to signals of potential difficulty and take steps to clarify points of confusion. Careful monitoring is particularly important at the beginning of the school year because misunderstandings about new policies are likely to show in the behaviors of students.

Effective monitoring requires that the teacher make a conscious effort to constantly scan the entire classroom. Some teachers monitor a few students or focus attention on

an individual who is misbehaving or having difficulty. These poor monitors tend to become engrossed with assisting one or a few students and seldom look up or scan the room. Such teachers re-focus on the entire group only when a loud noise or disruption occurs. At that point they may no longer be able to prevent misbehavior and can only react to it. A more effective technique would involve the teacher's moving to a position in the room where assistance can be given to an individual or group (Evertson and Emmer, 1982).

### *Managing Space, Time, and Resources*

Most art teachers have some sense of the relationship between environment and behavior. For example, many teachers change student seat assignments when a change in behavior is needed, or these teachers move misbehaving students closer to the front of the room to "keep an eye" on them. While the academic program is the central focus of most instructional efforts, the physical environment is an ever-present, yet often overlooked dimension of the educational milieu. Several reasons can be considered for this oversight:

1. Instruction-related business tends to consume a teacher's time and attention. In many classrooms, the spatial arrangement is made before the start of school, is assumed to be adequate for the academic program, and is not considered as an instruction-related factor.

2. The arrangement set before the start of school is assumed to be adequate for all conditions, and nothing obvious indicates to the teacher that a change is necessary.

3. To many teachers, changing room arrangements is disruptive, takes time away from the work at hand, and is only peripheral to the business of art education. On rare occasions, these teachers change the room layout to "put on a fresh face" and break-up the monotony of the ever-present environment.

The physical setting includes many variables that can be manipulated to support, be neutral to, or counteract the goals of a given lesson or activity. Overlooking the opportunity to manipulate these factors limits a teacher's resources for developing a robust and stimulating environment that can serve to enhance motivation and reinforce positive behavior patterns. Since physical space variables are under the direct supervision and control of the art teacher, they await thoughtful use as an important instructional tool.

Researchers and scholars in a variety of disciplines have studied how individuals react to different aspects of physical settings. From such investigations of classrooms, we have learned that the only spatial variable currently associated with improvement in academic achievement is student seat location. Students seated near the front and center of the room tend to earn higher grades, are more attentive, and engage in more task-related behavior than their counterparts in other parts of the room (Weinstein, 1979). Researchers have also pointed out that the most effective environments are

specifically planned and arranged to support the activities expected to occur within those spaces.

The notion of carefully planned environments is a serious consideration in business. In the corporate sphere, human-factors engineers are asked to design environments that provide the best "fit" between worker, task, and setting. The term *ergonomics* is often used to describe this realm of inquiry. The intent of such research is to study the physical conditions that maximize worker output while minimizing fatigue, distraction, and lost time. How individuals use available space as well as tools, time, and materials; the effects of noise, light, and color; and factors related to safety, fatigue, and stimulation are the focus of these studies. The results provide a basis for creating work places that are conducive to high levels of productivity, physical comfort, and safety. Corporations that invest in such studies believe their investments will result in loyal and contented workers who help the company produce higher earnings while reducing costs associated with accidents, absenteeism, and burnout.

In art education, ergonomic principles can be used to develop settings that facilitate the attainment of instructional goals and the prevention of discipline problems. Four basic concepts can be considered when planning environments:

1. There is no ideal or single best room layout that will satisfy the spatial requirements for every lesson. Since art education includes many instructional components, the setting must be planned in advance to best support the activities intended to take place. The spatial needs of students who are producing works of art are different than for those responding to work created by others. The arrangements for such diverse activities as presenting a demonstration, viewing slides, making pots, or critiquing works of art require different spatial considerations. For any activity, the layout of the room must take into consideration the teaching strategies to be used and the types of student involvement expected.

2. The arrangement of a well-organized classroom (furniture configuration, traffic patterns, demonstration areas, etc.) must be planned in advance, like other aspects of the lesson. While the ebb and flow of a lesson are sometimes difficult to anticipate, room arrangements must be flexible enough to accommodate the changing character of the lesson and the shifting needs of students.

3. The overall classroom must be imagined as an integrated instructional setting that reflects concern for both physical and social factors. Work stations can be organized to minimize potential conflicts among students when they must share work space and tools; also similar activities and behaviors can be grouped in one area to allow for efficient use of resources. In this approach, the mess and clean-up associated with different materials is isolated into specific areas. For example, when students make relief prints, separate stations can be specified for cutting plates, editioning, storing wet prints, and cutting mats. When planning efficient environments, decisions about where to locate stations should be based on such factors as the proximity of sinks, the need to obtain and return tools, and the accessibility of drying racks and clean areas.

4. Although the environment does not "teach," the way room spaces are arranged signals the expectation for certain behaviors. For example, when students enter a classroom and see chairs or desks lined up in rows and columns in front of a projection screen, the students expect to sit in chairs and look ahead. This notion can be helpful when signaling students about the activities planned for a daily lesson or when indicating a change from one activity, lesson, or unit to another.

*Arrangement formats.* Preparing arrangement formats that support instruction involves considering the type of activity expected to take place and the type and frequency of interactions that will occur between and among the teacher and students. Feitler, Weiner, and Blumberg (1970) identified a series of floor plan arrangement formats commonly found in classrooms and described the advantages these formats offered teachers and students:

1. The row and column configuration places students in a highly structured situation. This layout works well for directing attention to a specific location for lectures as well as for viewing slides, films, and other visual aids. The front of the room is the focal point and the teacher is well positioned for monitoring. This is a high-control format where order and control are emphasized while discussion and exchanges among class members are discouraged.

2. The horseshoe/circle/semicircle plan is well suited for discussions because class members can easily talk to one another. In this format, the teacher is well positioned to control and monitor. Presentations by individuals and exchanges among class members can be well accommodated.

3. The modular plan places students in small groups or clusters. This is an arrangement often found in art classrooms. Typically, it includes tables that seat four or more students or individual desk units that are pushed together into groups of three or four. Many times, students are facing each other, and some may have their back turned toward the front of the room. This is a low-control format that is well suited for independent work, individualized instruction, and peer teaching. In this arrangement, students tend to have more interactions with classmates than in other formats.

When planning work spaces, an awareness of different needs and preferences can enhance the promotion of task-related behaviors. For example, while many students function well in small, confined areas, others work best when they can spread materials out. Likewise, many students are able to "screen out" noise and commotion and are not bothered by nearby distractions.

At home, these individuals would be recognized as working productively while a television set flickers or a stereo blares nearby. On the other hand, "non-screeners" have difficulty ignoring environmental distractions and are comfortable working only when their surroundings are quiet and orderly (Heyman, 1978).

A related problem is the "visual bustle" created when passers-by on their way to the sink or storage cabinets create distractions for students seated along walk ways. To prevent such problems, room layouts and general procedures can be devised so students can obtain supplies, use special equipment, and store projects while minimizing the time the students are out of their seats. Arrangements that prevent bottlenecks in high traffic areas, such as around the teacher's desk or sink areas, should also be considered.

When a good "fit" between the student, the environment, and the work task occurs, high levels of satisfaction and a productive atmosphere can be expected. When a mismatch occurs, much of the students' energy is expended on merely coping with ambiguity and distraction.

Many art teachers share their classroom with a colleague. In such circumstances, a "home base" arrangement system should be considered. Once a mutually agreed-upon "home base" room arrangement is set, the corner locations of major furniture pieces are marked with tape on the floor. Then, desks, benches, or tables can be moved to other locations (possibly marked with different colored tapes), and returned to the "home base" spots before dismissal. In this way, room spaces are kept flexible while differing instructional needs are accommodated. After the procedures have been practiced a few times, they take only seconds to perform and can be accomplished with minimal disruption.

*Time.* In classrooms, time is a major resource under the control of the teacher. For example, most teachers are aware of the importance of time on task: Research shows that time spent thinking about and working with the content increases achievement and minimizes behavior problems. Keeping students on-task requires that teachers be constantly involved with the lesson and the students. By moving around the room, providing verbal and nonverbal directions, assisting those having difficulties, and helping any who are finished begin another task, teachers are effectively using class time (Kindsvatter, Wilen, & Ishler, 1988).

Observers in classrooms regularly tell about the amount of time they have seen being spent on activities not related to instruction. They describe how time is lost at the beginning of the class on routine housekeeping duties such as organizing materials, preparing projection equipment, and making preparations for a demonstration. Keeping students waiting wastes class time and sends the silent message that their position is subordinate or dependent. To be kept waiting for a long time is to be the subject of an assertion that one's own time (and worth) is less valuable than the one who imposes the wait. Students resent being made to wait but are not likely to verbally express their feelings. Their resentment may be expressed through misbehavior or other acts of disrespect.

Time is also lost near the end of the class period as students begin cleaning-up before being directed to do so by the teacher. Attention to how time is used during these periods of transition will assure that an important instructional resource is conserved while minimizing the potential for misbehavior that occurs when students have nothing to do. To guide decisions about how time is used, consider:

• the amount of time spent getting the class under way;

• the factors that influence when and why students stop working; and

• the extent to which time spent performing a task is in proportion to the importance of the task (Henley, 1977).

## THE NONVERBAL DIMENSION

Eye contact and facial expressions, how space is arranged and used, the extra linguistic elements associated with speaking, and the use of time are parts of the unspoken language referred to as nonverbal communication. This silent exchange provides the sub-text for understanding expectations and feelings. Nonverbal elements are difficult to fake, yet serve to intensify meanings and influence interactions.

*The dynamics of eye contact.* Everyone seems to agree that eye contact is important, but it is an often overlooked and poorly understood aspect of classroom communication that involves both the speakers and listeners. During verbal interactions, speakers tend to look at listeners in the eyes and around the face, in a series of instantaneous glances, seeking to get an idea of whether what has been said made sense to the listener. Some speakers pause to wait for a nod or gesture which indicates that all is going well and that they should continue. When a speaker perceives that a listener is confused, progress slows and the speaker restates a point or gives an example. Again, the speaker awaits a signal to proceed before resuming. Some speakers ignore feedback and press on regardless, not looking for signals one way or another.

Listeners attempt to "read" facial expressions, looking at changes in the small muscles around the speaker's eyes, mouth, cheeks, and forehead for subtle clues that will help them get a handle on the meanings the speaker is trying to convey. Sustained eye contact, such as staring, makes people uncomfortable so glances tend to bounce around rather than fix on one feature. Many eye behaviors are subtle and occur in split seconds. In our culture, eye behaviors are usually unconscious actions that are learned over time.

Speakers and listeners located in close proximity to one another during verbal exchanges are able to clearly see facial expressions and benefit from the nonverbal information conveyed. In classrooms, students seated close to the teacher are well positioned to see the small indicators that transmit meaning. Classmates in distant parts of the room or at severe angles to the speaker, or those not paying attention are less likely to be involved in the communicative give and take.

*Personal space and territories.* The distances people maintain between themselves and others are mainly determined by four overlapping variables:

1. The setting.

2. The relationships of the individuals.

3. The task or activity.

4. The emotions involved.

Anthropologist Edward Hall (1969) has identified four basic zones that summarize interpersonal distances and how they relate to the types of behaviors common to our culture. In classrooms, these zones have a direct bearing on the communicative exchanges that occur between teachers and students and can be helpful in understanding how students relate to space and distance in various classroom situations:

1. Intimate Distance.

   a. Close phase, 0 to 6 inches: This is the distance for the most personal interactions, which often involve body contact such as touching or comforting.

   b. Far phase, 6 to 18 inches: This distance is for less intense contacts and is often observed in public situations. For example, in crowded hallways and elevators, defensive behaviors such as avoiding eye contact or assuming certain postures are intended to counteract close encounters with strangers.

2. Personal Distance (The distance we maintain between ourselves and others).

   a. Close phase, 1.5 to 2.5 feet: This distance is for people bonded in some way such as teacher and students. In this range, facial features can be clearly seen.

   b. Far phase, 2.5 to 4 feet: This is the usual distance for comfortably discussing subjects of mutual interest or for such activities as ordering food in a restaurant. In this phase, voice levels are moderate.

3. Social Distance.

   a. Close phase, 4 to 7 feet: For impersonal business, this distance tends to be used by people who work together.

   b. Far phase, 7 to 12 feet: This distance is for formal business, such as when participants are personally uninvolved.

4. Public Distance.

   a. Close phase, 12 to 15 feet: This distance is for such impersonal business as a speech or presentation to a small audience.

   b. Far phase, 25 feet or more: For this distance, speech amplification or theatrical gestures are often used.

These zones or distances and the behaviors associated with them are unconsciously triggered in individuals as they go about their daily lives. Eye contact and interpersonal distance are the primary nonverbal elements involved in communicative exchanges. Consider this example:

> An art teacher is introducing her eighth grade class to a unit on drawing. To generate interest in the topic, she is using an overhead projector to demonstrate pencil techniques. Her 24 students are sitting in clusters of four. Twelve are directly facing the screen while the others have their backs turned away from the front of the room. Surprisingly, most of the students facing away show no inclination to turn their chairs around to face the screen and only occasionally do they glance toward the teacher. Most sit passively, occasionally whispering to one another, rarely looking toward the major focus of the instruction.

Assuming that the teacher described here is a committed professional who has carefully planned the instructional program, she has unintentionally created a series of circumstances that diminish the effectiveness of her lesson: She has overlooked the role played by nonverbal factors. Most teachers tend to concentrate on pedagogical and interpersonal issues, ignoring the silent messages transmitted by space, eye contact, and other nonverbal elements (Weinstein, 1981).

Careful examination of the situation just described indicates that various spatial and nonverbal elements are interfering with effective communication:

1. The teacher is unable to have eye contact with half of the class because they are facing away from the front of the room.

2. The arrangement plan places many desks at considerable distance from the front of the room, making it difficult for students to watch the teacher as well as to observe details and subtleties in the examples she is showing.

3. The students who are facing away from the screen are omitted from the instructional program. Ignoring these students can an invitation for inappropriate behavior.

One way to create a more suitable setting for this lesson would be to arrange the seating into a row-and-column arrangement. All eyes would be directed to the front of the room, and the projected images would be the focal point. From a front-and-center position, the teacher could monitor the behaviors of group members, and the pace of the presentation could be adjusted as necessary.

Another way might involve instructing students to gather in an area near the front of the room, perhaps around a demonstration table. If students are arranged so they are close to the teacher and able to see the screen, they can make eye contact easily and can be invited to ask questions and discuss the information being presented. When the presentation concludes, students return to their seats and resume individual work.

Another aspect of personal distance in the classroom is the distance teachers establish between themselves and individual students during one-to-one encounters. Close personal attention directed at students usually sends powerful messages. For example, when a teacher stands close to a student, compliments seem more genuine, scoldings more severe.

*Personal territories.* To understand how individuals claim and use space in classrooms, an awareness of territoriality can be helpful. The practice of designating a certain space for personal use and securing it against invasion or takeover by others is referred to as *territoriality*. This concept of human behavior has evolved from studies of animals in their natural habitats. Scientists have noted that certain species lay claim to an area, mark it in some way, and defend it against invasion by others. Anthropologists tell us that the practice of identifying and securing personal space is essential to the survival of the human species because it assures a reasonable degree of safety, provides a means for controlling resources, and in some cases affirms an identity or group membership.

In classrooms, territorial identification and marking occur regularly by both students and teachers. These practices occur as normal behavior and are accepted almost without question. Students place pencils, books, jackets, or other personal items on desks, chairs, or tables as a way of signaling others that "this space is taken." The objects are often spread around the identified area to denote the size of the space being claimed. Invasion of this space by others or misunderstandings about occupancy can be a basis for disagreement.

Teachers often identify a territory in front of the classroom with their desk and mark it with items such as a name plate, books, papers, and personal belongings. This territory is expanded by positioning file cabinets, display cases, book shelves, and other furniture around the desk. In some cases, the desk is further separated from students by an aisle that serves as a buffer zone that also defines the perimeter of the teacher's territory. The psychological mechanism behind this behavior may come from the belief that one's person does not end precisely at the extremities of one's body (Heyman, 1978).

While territorial identification is not central to the instructional process, such identification tends to symbolize and accentuate the position of authority occupied by the teacher. The development of student-oriented classrooms may be unknowingly undermined by an overemphasis on the teacher's personal territory.

Classroom spaces, especially those occupied by the teacher, need to be kept flexible so that the shifting character of a lesson allows plenty of room for different activities. Classrooms encumbered by an overemphasis on teacher territories limit change and the adaptation of an environment to the needs of students. Just as diversity in instructional methods can arouse the interest of students, attention to the spatial features of a classroom can encourage growth.

Planning environmental arrangements ultimately involves taking into account the nature of the activity to occur, the limitations imposed by the furnishings, and the communication exchanges expected to occur. Because of the diversity of options and

the preferences of individual teachers, the best arrangements for a given lesson will ultimately result from a process of experimentation. To prepare the most advantageous behavior setting for any lesson, art teachers must develop a repertoire of strategies and techniques that merge their own personality and value system with the characteristics of the lesson and the preferences of students. The environments created will include a combination of physical and spatial qualities that set the stage for learning.

### Teacher Behavior

Through the strength of their personality and the way they treat students in and outside of the classroom, art teachers influence how their students behave. While a businesslike and purposeful approach sends a message that order and a focus on the task at hand are important, teachers who show concern for their students, a healthy sense of humor, and a steady demeanor tend to create comfortable and productive classrooms.

Respect for students can be shown in a variety of ways, including:

- acknowledging students and using their names in contacts in the halls, lunch room, or the local supermarket;

- attending school-related events such as athletic contests, honors programs, and band concerts;

- referring to the participation of class members in school-related events and making note of upcoming games, plays, or concerts; and

- writing constructive notes and comments about students' work (Kindsvatter, et al, 1988).

### Teacher Identity with the World of Art

An art teacher's understanding of and identity with the world of art is an often overlooked factor that can influence how students behave in the art room. The bonding that occurs between students and the art teacher can lead to an internalization of school-appropriate behavior. These associations can be developed in various ways, including the following:

1. Use the news and feature items that appear in the newspapers and on television as a basis for discussing how art touches our lives each day.

2. Exhibit work and attend lectures and conferences, which nonverbally inform students of their instructor's commitment to the arts. The implication is not that an art educator must be unusually talented as an artist. Rather, students begin to recognize that their teacher has expertise, insight, and dedication to art that goes beyond classroom talk.

3. Discuss the struggles and frustrations associated with producing works of art and emphasizing the importance of such traits as determination, perseverance, and

hard work. Candid reference to how ideas are initiated, developed, transformed, and refined can be included in explanations of how works of art evolve. The process includes overcoming mistakes and confronting uncertainty.

### Developing a Sense of Ownership

According to Lasley (1986), students' willingness to follow rules and engage in lesson activities will be enhanced if they are given opportunities to have "ownership" in the classroom culture. Students who believe they are part of the classroom culture are likely to see themselves as belonging while being less inclined to misbehave. Students who are excluded from involvement tend to view the classroom as belonging to others and may be more inclined to treat others with disrespect.

A variety of means are available to enhance the perception of ownership. Participation in collective decision making is one. For example, the teacher and students can jointly participate in formulating classroom rules. Efforts must be made to assure that everyone has an opportunity to participate. This will mean giving students chances to write suggestions as well as voicing concerns through discussion. Students are more likely to accept and obey standards they have had a hand in setting. Similar approaches can be used when defining policies and in establishing routine procedures.

### Preventive Practices

As part of their studies of classrooms that were characterized as smoothly functioning and those in which inattention, misconduct, and constant disruptions were common, Kounin (1970) and his colleagues analyzed video tapes to identify the practices commonly used by effective teachers. The researchers discovered many subtleties in the ways problems with student misconduct were handled. The approaches used to minimize the frequency and extent of disruptions included the following:

1. "Withitness:" Effective teachers constantly monitor the classroom, spotting problems before these situations can escalate into disruption. By stationing themselves where they can constantly scan all parts of the room, they let students know their teacher is "with it" with regard to what is happening. This technique is an early warning system for spotting inappropriate behavior before it escalates into a more significant problem.

2. Overlapping: Effective teachers are able to do more than one thing at a time. For example, when conferring with one student, they continue to monitor events going on in the rest of the room. While helping the individual, they continue to observe the overall classroom and respond to questions, but in ways that do not disrupt others.

3. Continuity and momentum: Whether teaching the whole class or a small group, effective teachers are well prepared and thus able to move briskly through an activity. They have props ready when needed, are prepared for what comes next,

seldom have to backtrack to present information that should have been presented earlier, and rarely stop to consult their lesson plan. Serious inattention is dealt with before it can escalate into disruption, but in ways that are not in themselves disruptive. These teachers move near inattentive students, use eye contact when possible, or cue inattentive students with a direct question or comment. Such teachers tend to not interrupt the lesson to deliver extended reprimands that would focus attention on the problem students. In general these methods are effective because students are usually attentive when presented with a continuous academic "signal." Problems tend to arise when students have no clear signal to respond to or no specific task to focus on.

4. Group alerting and accountability: Effective teachers use presentation and questioning techniques designed to keep the class alert and accountable. One technique involves keeping students in suspense as to who will be called on next. These teachers get around to visit everyone frequently, ask for volunteers to raise their hands, throw out challenges by declaring that the next question will be tricky or difficult, and call on listeners to comment on or correct a response. The idea is to keep students attentive by conveying the idea that something new or exciting could happen at any time.

5. Variety and challenge: Students tend to spend a majority of their time in the art classroom working independently rather than under the direct supervision of the teacher. The extent of their interest in the assigned work influences the quality of their engagement with specific tasks. The variety necessary to stimulate interest is often achieved when the assigned work offers a sufficient level of difficulty, yet is different from previous work.

The effectiveness of a teacher's efforts to prevent discipline problems results from a combination of instructional practices and his or her long-term relationship with students. McDaniel (1986) offers a series of general guidelines and suggestions for group management and control that focus on teacher practices. His suggestions include the following:

1. Use the principle of focusing when introducing new material. Teachers must insist on having the undivided attention of all class members before giving instructions or presenting material. Trying to teach over a room full of talking, inattentive students is futile. Expecting students to know that they should get quiet and pay attention without being told may be unrealistic. To begin the process of focusing their attention, a teacher can say something like, "In a moment I will begin to explain how to use the scratch knives. Before I start, everyone must be sitting quietly and looking at me. I will be telling you things you will need to know to be successful with your scratchboard drawing." In some cases, a specific directive may be necessary. "Bob, we are waiting for you to get quiet." Having everyone's attention before starting the presentation and not starting before that is achieved is essential. The point is that during group

instruction the teacher must request, demand, expect, and wait for attention before beginning to teach.

Once an acceptable level of attention has been attained, the teacher can present the actual instruction in a calm and controlled voice. While somewhat authoritarian, such an opening need not be repressive or demeaning. To further focus attention, a handout or work sheet that outlines the content to be covered can be prepared. Students can be instructed to follow along and write in or draw the information presented. When appropriate, these handouts function as advanced organizers and study guides as well as tools to focus student attention.

2. Use direct instruction to get students engaged in work and keeping them involved in task-related activity so they have something to do at all times. To address this goal, clearly state the assignment, the directions, and the time constraints. For example, the teacher might say, "The assignment is listed on the chalkboard. Look at the reproductions on the display panel. You have 10 minutes to work, so start immediately." The teacher's efforts should focus on making the tasks interesting and relevant.

3. Keep a constant check on student performance and behavior (monitoring). One way to do this is by circulating among class members, making personal contact with each student at least once during every class period. Students quickly become aware that their work and behavior will be monitored and evaluated from close range. These conferences with each student provide opportunities to evaluate his or her progress as well as to receive feedback about the effectiveness of different teaching techniques.

4. Use the principle of modeling to set a positive example for students. Teachers who are courteous, prompt, well-organized, enthusiastic, and patient can have a strong influence on their students. Likewise, the use of a soft, low-pitched voice and "soft reprimands" are effective because they usually do not invite loud protests, denials, or retorts.

5. Use nonverbal cues to remind students about behavioral expectations. For example, raising a hand for silence or pointing to a group of talking students and pressing an index finger to the lips remind students of a specific expectation. When some students seem oblivious to subtle cues, stronger, more efficient signals may be necessary. In some cases, teaching nonverbal cues to students may be necessary. Creative teachers can develop a repertoire of techniques that include proximity, facial expressions, and gestures to supplement usual visual and verbal cues.

### Transitions

Kounin's (1970) work has established the importance of maintaining a continuing academic focus for students' attention and avoiding time when they have nothing to

do. This concept is especially significant in art classrooms because students often finish projects at different times. It sometimes seems that the project has just gotten under way when one student is already finished.

Making transitions from one assignment to the next as seamless as possible is important in an orderly classroom. Clear directions about what will happen when the lesson or activity concludes can be given at the start of the activity. This information enables those who finish early to make a smooth shift to the next assignment. A well-planned transition ties activities and subjects together in a logical manner (Kindsvatter, et al, 1988).

To minimize the problems associated with transitions, art teachers have several options:

• Devise a series of short assignments or activities that reinforce or review a concept or idea from the lesson just completed. For example, students can design a flier or small poster announcing a show of the work. Guidelines can be prepared in advance to assure that students have sufficient direction.

• Prepare an enrichment center in a corner of the classroom that is stocked with art-related books, postcards, posters, and magazines.

• Develop a series of file cards that outline activities students can work on without direct instruction by the teacher. These activities can relate to the lesson just completed, a previous area of study, or a separate topic.

The approach used should reflect the teacher's preferences, beliefs, and priorities for what is important in an art lesson. What works with one group of students may not be realistic for another. In any case, students should be expected to follow established standards for personal conduct.

### Contracts

Teachers who wish to shape student behavior through reinforcement are advised to consider the use of formal contracts. Brophy (1983) describes the use of written agreements as an approach to discipline that places the major responsibility for behavior on the student. In their simplest form, these are not legally binding contracts. They specify standards that must be achieved to earn a certain grade, award, or privilege. In addition to providing a problem-solving approach to academic performance, this method can also be used to identify and specify aspects of personal conduct. Contracts enable teachers to individualize arrangements with students while placing an emphasis on self-control, self-management, and self-instruction. This approach to setting goals can give students an opportunity to focus their attention on tasks they identify and agree to pursue.

When preparing the actual document, language can be developed to reflect such factors as the dates progress will be checked, the form the final body of work will take, and criteria that will be used for evaluation. Other content may refer to specific behavioral expectations, the preparation of sketches or other preliminary materials, or

the expressive features to be included in the work. Contracts can be prepared so that the student works for a specific grade, based on the performance options developed between the teacher and student. Clauses can be developed for each student based on the characteristics of an individual lesson, unit, or grading period. Penalties for failure to meet the standards and the conditions for re-negotiation can also be included.

The preparation and refinement of contracts as a tool for dealing with student behavior, like other forms of educational enterprise, will improve through experimentation. Contracts can be especially helpful for students who are poorly motivated, easily distracted, or resistant to school work.

### Options

Students appreciate the opportunity to choose the work they will do to fulfill course-related responsibilities. By being offered a series of options, students can choose a means for engaging in art activities that accommodates their skills and preferences. For example, a lesson in portraiture can include choices of media, scale, and visual reference. In some cases, students can be invited to submit a proposal that outlines how they plan to work. In some cases, negotiation may be necessary. By offering options, the expressive potential of a lesson can be expanded as students acquire a measure of control and individuality. Options can be developed as part of an overall lesson plan or, in some cases, they can be offered as a reward or privilege.

### Conclusion

From research in the area of effective teaching, we know that preventing discipline problems involves maintaining a well-organized classroom and keeping students productively engaged in learning activities. Effective managers can be distinguished by their ability to create an orderly and structured classroom. These teachers work to prevent problems. This concept of prevention includes several sub-points:

1. Planning and preparation before the school year begins.

2. Implementing the plans in the first weeks of school through systematic communication of expectations and the establishment of rules, procedures, and routines.

3. Maintaining a consistent approach throughout the school year by presenting students with carefully chosen, well-prepared activities that focus the students' attention and engage their efforts.

4. Attending to behaviors and practices that reflect concern for their students' learning and academic well-being.

Research on teacher effectiveness in producing gains in student learning suggests that learning proceeds best when students enjoy high rates of success, in other words, when tasks are easy for them to do. When the teacher is present to monitor responses and provide immediate feedback, success rates can be expected to be quite high (Brophy and Evertson, 1978).

A variety of sources are available to further pursue specific ideas and concepts related to effective teaching practice. The professional literature provides detailed descriptions of how teachers organize classrooms, prepare for the school year, and manage classrooms on a daily basis.

As studies in art classrooms continue, the evidence obtained suggests the importance of a series of basic principles: showing respect for individual differences, tolerating individuality, assisting students with special needs or problems, and using persuasion rather than the assertion of power to solve problems. We must also recognize that students have responsibilities and must bear the consequences if students fail to fulfill those obligations.

Less research exists to guide decisions about how to counsel individual students, resolve individual conflicts, and tolerate misbehavior. As the knowledge base in teaching grows, art educators must continue to combine the unique character of the art instruction with strategies for effective management developed by colleagues in other disciplines. This need to synthesize ideas about teaching art with practices that promote efficient classroom management reflects the emerging role of art teachers as professionals who have unique knowledge and expertise, particularly in the area of managing the behavior of students.

**Part 3**
# STRATEGIES FOR ADDRESSING DISCIPLINE PROBLEMS

As discussed, the combination of well planned lessons and sound instructional approaches are keys to an orderly and well managed classroom. Teachers who experience few discipline problems can be distinguished by their ability to keep problems from happening in the first place. Their approaches tend to include the following:

1. Planning and organizing before the start of the school year.

2. Introducing and explaining their plan during the first days and weeks of school.

3. Monitoring the behavior of students to determine the extent of compliance and using corrective actions when necessary.

4. Following up on expectations and presenting students with a continuous stream of well-chosen activities that focus attention during group sessions and independent work times (Brophy, 1982).

Inappropriate behaviors thrive when ignored by the teacher. If such behaviors are allowed to continue unchecked, more and more students begin to violate classroom rules or fail to follow designated policies. Many become confused about what the proper behavior should be. By monitoring the behavior of students and stepping in quickly when misbehavior occurs, the teacher maintains the credibility of their rules and procedures (Evertson and Emmer, 1982).

### Systematic Approaches to Classroom Management

The continuing challenge of managing student behavior has forced many art teachers to search for reliable guidelines. In response to this need, a variety of authors have produced more than a dozen pre-packaged programs that offer the promise of consistent, systematic, and educationally sound management programs. These plans are known by various names, including "Assertive Discipline," "Teacher Effectiveness Training," "Reality Therapy," and "Dare to Discipline." Each has a defining set of practices and is supported by specific theoretical assumptions.

Studies of pre-packaged systems have provided mixed evidence of their effectiveness. Emmer and Aussiker (1989) reviewed research on four widely used programs and found some evidence of positive effects on teacher attitudes, beliefs, and perceptions; mixed evidence of a positive effect on teacher behaviors; and almost no evidence supporting a long-term positive effect on student behavior.

A teacher's efforts to establish and maintain order hinge on two interacting factors: that individual's personal style (a combination of personality, common sense, experience, and instincts) and his or her personal values and beliefs. To be effective, both sides of the equation must be in accord. Thus, the uniqueness of each individual teacher simultaneously predisposes and limits the discipline approaches that the person can use. This is especially true in situations where the practices being considered

run counter to that teacher's personal values and natural inclinations (Kindsvatter, et al, 1988).

The most popular pre-packaged programs offered in the literature present teachers with a variety of options. *Assertive Discipline* (Canter, 1976) takes the position that the teacher is in charge in the classroom and no student has the right to interfere with the instructional program. It calls for high profile but non-hostile interventions that transmit the teacher's expectations for behavior. A series of pre-determined rewards for compliant behavior and penalties for misbehavior are provided. When a rule is broken, the teacher follows through with consistent consequences. An assertive teacher communicates expectations to students through clearly stated and carefully defined rules. When a violation occurs, the teacher engages in repeated requests for compliance, becoming a "broken record" that cannot be ignored. This model reflects an obedience orientation that is popular because it presents a definitive set of procedures that place the teacher in control.

*Teacher Effectiveness Training.* Gordon (1974) emphasizes replacing repressive and power-based methods (punishment, blaming, threatening) with a series of learned behaviors based on (1) active listening and responding to the feelings and content of the behavior; (2) I-messages (I want you to...) for responding to misbehavior; (3) problem ownership—understanding the differences between misbehavior and situations in which the learner has no real problem but is behaving in a manner that is causing the teacher to have a problem; (4) negotiation, problem solving, and the use of a collaborative, no-win, no-lose approach to resolving classroom conflicts and establishing rules and policies.

*Reality Therapy.* Glaser (1969) advocates that students find ways to deal with the world as it really is. This approach claims that disruptive events occur in classrooms when students lack involvement with the school, when they feel unsuccessful, and when they do not take responsibility for their own actions. In this view, the school should try to eliminate situations where failure can occur and try to increase involvement, relevance, and thinking. Responsibility is learned through a positive, emotional involvement with a responsible person. Teachers must be positive and responsible individuals who are trained to implement a series of steps for conducting classroom meetings that ultimately lead to student involvement in decisions about classroom policies.

*Project Teach.* Project TEACH (1977) combines a variety of strategies, skills and approaches. The training includes skill development in both verbal and nonverbal communication, positive reinforcement and related behavior modification principles, changing the environment, a system of natural and logical consequences, and assertiveness by the teacher. This eclectic approach attempts to combine some of the best features of several systems and philosophies.

*Dare to Discipline*. Dobson (1971) emphasizes an authoritarian approach that gives the teacher "absolute locus of control." The teacher is expected to be businesslike, highly organized, and in firm control of classroom events. From the first day of school, the teacher needs to let students know who is in charge.

The efforts by school administrators to help teachers implement these systems tend to be dominated by in-service programs. Many include elaborate presentations that feature video taped scenarios, published materials, and activities carefully designed to reinforce central concepts. The major drawback of such programs centers on their over-reliance on a single strategy for addressing complex problems while discounting the teacher's experience and judgment in circumstances where teachers know their students well (Gotfredson, 1992).

A systematic approach discussed by Kindsvatter, Wilen, and Ishler (1988) focuses on using the individual teacher's knowledge and experience in combination with an informed system of beliefs and values. Central to this approach are the following concepts:

1. Instructional practices are based on humane and democratic principles.

2. The teacher accepts responsibility for providing every student with realistic opportunities for personal success and emotional comfort.

3. Students are expected to cope with reasonable conditions and responsibilities. When students do not respond in appropriate ways, they must be dealt with in a firm and fair manner.

4. The teacher believes that students need the guidance provided by enlightened adults.

5. Classroom policies and practices reflect an understanding of the concept that teaching is a blend of both science and art. The scientific aspects of teaching include practices that build upon objective, research-based knowledge in such areas as motivation, child, and adult development, learning styles, positive reinforcement, and effective instruction. The "art" of teaching results from the creative and unique ways a teacher implements and personalizes the scientific aspects.

When applied in classrooms, the teacher's belief system and instructional artistry interact to provide the basis for making decisions and implementing measures intended to guide and manage student behaviors. The product of this convergence can be designed so that the following will result:

1. Students' personal and social development are emphasized over merely learning how to comply with rules and directives.

2. Students are encouraged to learn self control and obtain a sense of personal responsibility for their actions based on established norms of behavior.

3. In cases of misbehavior, every effort is made to preserve the dignity and self respect of both teacher and student. When a behavior problem arises, the idea is to take the high road, maintaining an elevated level of professional poise. The focus is on the act, not the actor—on what the student has done, not on his or her personality, academic record, or appearance. The point is to confront the problem in an elegant, smooth, and slightly detached manner, much like a physician approaches a health care situation.

4. Actions that might further aggravate the problem situation are avoided.

5. The potential for undesirable secondary effects that might be created from any disciplinary action are minimized.

### A Proposal for Systematically Addressing Misbehavior

Experienced teachers acknowledge the importance of prevention as the single most crucial step in any fully developed strategy for maintaining an orderly classroom. However, when a situation arises that is beyond preventive measures, a sequential, somewhat structured decision-making system can be helpful. Kindsvatter (1979) outlines a multi-step sequence that can be adapted for use in a variety of classroom situations. The steps include the following:

1. Consider the problem at hand in clear and dispassionate terms. When misbehavior occurs, some of the following conditions are likely to be present:

   a. The teacher is likely to feel frustration and/or anger because a student's actions are disrupting the development of a positive learning environment. An impulse to retaliate is likely to be the first reaction.

   b. Disruptive behavior often includes strong emotional overtones. Maintaining poise and self control is absolutely essential so that a thoughtful and objective analysis of the circumstances can be made. The first reaction of the teacher must be to quickly size up the situation without making unwarranted assumptions. The conditions that triggered the misbehavior must be quickly identified. Overreacting may only delay or dilute the use of other, more effective measures.

   c. Under-action is preferable to a quick reaction which may violate one or more of the tenets to which the teacher intends to subscribe. In general, when an intervention is needed, one's response strategy should start with the mildest form necessary to be effective, moving to stronger measures only as necessary. Discretion, prudence, and restraint should be the watchwords when considering actions to take.

   d. A disruptive student should be looked upon as a troubled youngster who is exhibiting the symptoms of a personal problem. The point is for the teacher to proceed with restraint, judiciously using the power available to him or her. By

blending firmness with compassion, treating the student much like a physician treats a patient, the teacher tries to solve the problem without making the patient worse.

2. While remaining composed and objective, move as quickly as possible to quell the disturbance and restore order so that learning can proceed. While an infinite number of approaches to discipline problems are possible, the teacher should have in mind a graduated list of possible responses to as many types of misbehavior as can reasonably be anticipated. The minimum level of power that is likely to suppress the misbehavior in question should be selected initially with the option of moving on to increasingly stronger applications as warranted. A sequential list of responses might include:

   a. making eye contact with the affected students while continuing regular classroom activity;

   b. sustaining eye contact, pausing, and/or delivering a subtle glare;

   c. physically moving to the location of the disturbance;

   d. stating the student's name and directing him or her back to the learning task;

   e. asking a question or using some other approach to make sure the student understands what he or she is supposed to be doing;

   f. giving a verbal reminder of the expected behavior and redirecting the student back to the task at hand;

   g. privately asking the student to remain after class;

   h. with minimum fanfare, moving the student's seat location (as appropriate) or sending him or her to a designated "time out" place;

   i. speaking to the student in the hallway or at the teacher's desk while keeping an eye on the class; and,

   j. again with minimum fanfare, assigning an after school detention.

   An inviolable rule: The teacher must avoid the negative attention created by directly confronting misbehaving students in front of the entire class. Some students behave in ways they hope will draw attention to themselves. The disruptions they create put them in a spotlight they crave. Overreacting can easily escalate a minor problem into a confrontation that only serves to undermine the value system the teacher is trying to build upon.

   The preferred approach is to use a low profile manner to speak to misbehaving individuals. The point is to not draw attention to the misbehavior or the student. When possible, this should be done in private, away from the ear shot of others. Situations that require further action should be pursued after class. At that time, the teacher can interview the student to obtain a sense of why the behavior occurred. When a specific disciplinary action is taken, the student should be given a rationale for the measure used.

Situations sometimes arise in which class members virtually ignore the teacher's directives and efforts to maintain order. In such circumstances, the teacher may be unable to control the educational program in that classroom. These are complex situations that may require the assistance of colleagues or other courses of action. An appropriate course of action may involve consulting with other teachers, counselors, or administrators to gain assistance and insight in understanding the levels of the problem. In some cases, a student who is misbehaving in the art room is having similar problems in other classes. If other teachers have experience with the student and have discovered effective ways to manage that individual, strategies that have worked before should be considered. Sometimes the problem may reside within the teacher. Assistance from other professionals may be needed to prevent serious repercussions.

3. Select a response from the set of alternatives that has the greatest promise of resolving the discipline problem, while conforming to the tenets of the teacher's belief system. Cases of minor misconduct may warrant only a gentle reminder. Serious disruptions or persistent misbehavior requires follow-up by the teacher. In such cases, the teacher can select from such strategies as the following:

a. Confer with the student outside of class time.

b. Call the student's parent to exchange information and try to arrange for a "two front" approach. Perhaps the most underutilized resource available to teachers for dealing with disruptive students is parents. The input and cooperation of these adults can be an important tool for dealing with pupils experiencing chronic behavior problems. Some teachers are reluctant to involve parents because of uncertainties about the support they will give. These concerns can be offset by the need to focus on the causes or motivations behind the misbehavior. Teachers are in a good position to identify problems and prescribe solutions (Lasley, 1994). Georgiady, Sinclair, and Sinclair (1991) describe a sequence for conducting a parent contact:

(i) Address the parent or guardian by his or her correct name.

(ii) Identify yourself and provide a neutral focus for the contact: "I'm Mr. Smith, and I'm calling about Chris' behavior in art class."

(iii) State specific behavior(s) in objective terms: "Today, Chris grabbed a classmate's drawing and threw it on the floor. She has done this several times in the past, and I am concerned about the pattern of misbehavior that seems to be emerging." Avoid subjective or judgmental comments such as, "Chris is very immature."

(iv) Enlist the parent's support by stating the desired behavior: "I'm sure you want Chris to respect the property of others and concentrate on her own work."

(v) Identify the parent's responsibility: "I believe it will help if you tell Chris to leave the property of classmates alone and do her own work."

(vi) Ask the parent for additional ideas: "What ideas do you have that I might use with Chris?"

(vii) Reinforce parent and teacher responsibility: "It will help if you tell Chris to keep her hands, feet, and objects to herself and concentrate on her own art work. Please remind her that failure to do so is the reason she must serve detention tomorrow. In addition, I will try to involve her in group activities."

(viii) State if and when a follow-up contact will occur.

(ix) Finish the contact on a cooperative note: "Thank you for your time. Please give me a call if you have any questions or concerns."

   c. Arrange a conference involving any parties who have an interest in the student or can contribute to the situation. In addition to parents, this could involve a coach, another teacher, or a trusted family member.

   d. Refer the case for more specialized attention. In some instances, psychological or medical factors may be at the root of the problem(s).

   e. Recommend in-school suspension, with continued attention to the student.

   f. Suggest a change of schedule, suspension from class or school, or expulsion.

4. As soon as possible after an incident, try to ascertain the conditions that precipitated the misbehavior. Suppressing misbehavior is not enough. If the teacher's discipline-related practices are to be educational, the student must understand what he or she did wrong and find acceptable alternative behaviors. In addition to speaking with the student, it is necessary to obtain more information about the disruptive student. In some cases, helpful facts can be obtained through review of school records, by speaking with other teachers and parents, and sometimes from what comes along the school "grapevine."

5. At this point, analyze the teacher's expectations for behavior. The norms established for the art classroom should reflect reasonable standards for the age group and developmental level. This analysis requires that the teacher clarify in his or her own mind what "decorum" means and which behaviors can be tolerated. In most cases these behaviors will include the student's paying attention when the teacher is speaking, using good manners and being courteous and considerate of others, and acting in responsible ways.

A teacher who is predisposed toward discovering the sources of discipline problems and addressing the issues involved in preventing and/or solving them has a head start on maintaining an orderly and controlled classroom environment. Such teachers have learned to recognize situations where misbehavior can occur, and these teachers make a point of pre-planning strategies for those instances. An awareness of the tenets just discussed can be a basis for consistent and effective discipline practices.

### Rules

The use of a workable rule system can be helpful in creating a positive, functional classroom environment. The best rules are reasonable and easy to understand and enforce. When developing rules, clear differentiation between specific, workable rules

("Remain in your seat unless given permission to leave it") and abstract, unworkable ones ("Show respect") is necessary. Teachers have considerable latitude when developing rules, from being an authority figure who sets rules, to using a democratic approach in which standards are adopted by majority vote at class meetings.

Effective implementation depends as much on instructional thoroughness as on skill in control and monitoring. Key procedures and routines can be taught to students much like academic content is taught. Taking time to explain expectations, answer questions, and model correct procedures will prevent ambiguity (Lasley, 1994). An extended discussion of the dynamics of constructing, teaching, and enforcing rules can be found in Canter and Canter (1992) and Evertson and Emmer (1982).

Many schools have established rules and policies that teachers are expected to enforce in common areas and classrooms. Building-wide guidelines represent an effort to create a consistent set of standards for student behavior while the students are on school property. In some situations, these expectations are unspoken rather than explicit, yet teachers are expected to know, understand, and support them. Because such informal expectations may be interpreted and enforced differently by teachers, inconsistencies are likely. Teachers who are new to a building should try to discover such expectations so that in cases of student misbehavior their actions are not in conflict with school policy.

### Keeping Records

Well maintained records of misbehavior by individual students are central to an organized and systematic approach to classroom management. Carefully prepared notes that describe the nature and severity of misbehavior can be helpful when discussing specific students with parents, counselors, or administrators. These records can also offer insights into patterns of behavior over time. A behavior data form prepared for an entire class, or individual file cards for each student can facilitate record keeping. Such specifics as the date, time, circumstances of the misbehavior, and related details should be noted. In some cases, audio or video recordings can be used to supplement the written documentation. A well developed body of evidence can provide insights into the motivations of individual students and may offer clues for neutralizing the problem.

### Punishment

In general, punishment is the means by which individuals attempt to gain control over the behavior of others by inflicting a penalty. When applied in classrooms, punishment can be thought of as retribution that involves physical pain or mental discomfort. Many educators believe that such practices are not appropriate in classrooms where concepts of personal dignity and a democratic society are being cultivated.

Kindsvatter, et al. (1988) state that teachers who routinely rely on punishment (or the threat of it) to obtain order are essentially failing in their managerial and instructive performance. The astute teacher recognizes the often subtle differences between the infliction of punishment and the need to confront students with the consequences of their

behavior. In many cases, reasonable consequences appear to be similar to punishment (i.e., mild censure, changing a seat assignment, redirecting off-task behavior to on-task). The distinction is simplified if the student is made to recognize the connection between the inappropriate behavior and the consequences of those actions. Responses to misbehavior must be reasonable and related to the offensive behavior. However, arbitrary punishments such as writing a phrase over and over or insisting that a student remain standing rarely meet the test because they have no redeeming educational value and are retributive in nature. Such actions have been shown to be largely ineffective as deterrents of future misbehavior. In some cases, these responses give the misbehaving student the attention they crave and may actually be counterproductive.

With regard to tangible rewards such as money or food, Cotton and Savard (1982) reported that temporary positive effects tend to result at first but soon give way to a long-range negative effect.

On the other hand, classroom conditions that provide students with positive academic and social success experiences tend to reduce discipline-related problems. The authors note that punishment per se is a generally ineffective technique for controlling misbehavior or obtaining positive behavior. Rather, the desired behavioral outcomes tend to result when the punishment is clearly related to the misbehavior and is recognized as such by the students.

### Dealing with Violent Behavior

Incidents of violent behavior by students are on the increase in schools, and the potential for violent acts is always present in classrooms. When such situations occur, both teacher and students are in physical danger. The student who appears out of control and shows indications of violent action presents even the most experienced teacher with a potentially difficult situation to handle. Some school districts offer teachers special training programs.

Although foolproof techniques for diffusing a student's heated emotions or hostile behaviors are not possible, some approaches can help. DeBruyn (1993) offers a series of guidelines for dealing with violent situations:

1. Avoid trying to overpower a violent student. If the student has any type of weapon, any physical effort to force it away may be destructive. Instead, remain as outwardly calm and composed as possible while showing compassion, understanding, and fairness. Resist issuing ultimatums or raising your voice.

2. Keep away from any student who is angry or upset, and avoid actions or behaviors that may be perceived as threatening or confrontational. When a threatening incident occurs, as quietly as possible and without fanfare, send another student to the office for help.

3. Perhaps most important, suggest that the student be seated or remain seated so he or she can explain what happened. Say, "I need to know what is wrong. Please sit down and talk to me." If you keep the student seated, the chance for an explosion

is greatly reduced. If you sit down first, you will signal that your purpose is to listen. When a violent student is standing, anything can happen.

4. Try to keep the student talking. Listen carefully and ask open ended questions to find out what provoked the action, and why and how the problem started. Only after the troubled student has had time to state his or her feelings should possible solutions be offered. When help arrives, try to ease the administrators or other officials into the situation.

Fighting is the most common form of violence seen in schools. When altercations occur, avoid stepping in between two angry students because you may take the beating. The preferred approach is to use a firm, businesslike tone and simply say, "Stop this immediately and get to class." Make no threats. If this is ineffective, send for help. Keep in mind that you are an authority figure. Most students have been programmed to respond to authority. The best course of action is reason, objectivity, and negotiation, not force.

Once the incident is over, it is your responsibility to document pertinent facts and as many specific details as possible. This documentation includes the names of the students involved, the location and time of the incident, names of witnesses, and the circumstances as you saw them. Also, note what you did and said. Present this information to your administrator.

### Conclusion

The problems associated with discipline in art classrooms are complex and wide ranging. An academic program that features creating works of art and responding to the works created by others provides a basis for a rich mix of content and behaviors. We have discussed how effective teachers work to make misbehavior unattractive by presenting interesting and engaging lessons and by keeping students engaged in the work at hand.

When behavior problems occur, some teachers succumb to personal dispositions, responding to problems emotionally rather than professionally. The professional literature offers a variety of pre-formulated measures that offer the promise of consistent and educationally sound approaches for structuring responses to misbehavior. While each has positive attributes, the major drawback of these approaches centers on their failure to incorporate the unique insights, experience, and behavior characteristics of individual teachers. On paper, the approaches look good but may not work well for specific teachers and their students.

The development, implementation, and refinement of a personal discipline plan should be the goal of well informed art teachers. Such an approach should be built on educationally sound concepts and reflect the teacher's personal style and belief system.

While many ideas and suggestions for managing art classrooms and controlling behavior are offered here, how these concepts are understood and used in specific situations will depend on individual teachers. Misbehavior is a part of classroom life and is unlikely to

go away. In a larger view, misbehaving enables students to explore their potentials and acquire an awareness of their limitations. In response to this reality, creative and inventive art teachers must internalize concepts, organize resources, select approaches, and apply skills that emphasize student achievement while minimizing misbehavior.

# REFERENCES

Anderson, E. (1994). The code of the streets. *The Atlantic Monthly, 273*(5), 81-94.

Barker, H. (1994, March 28). Unruly kids cost others their right to learn [Letter to the editor]. *Akron Beacon Journal*, p. A-11.

Bauer, G. (1985). Restoring order to the public schools. *Kappan, 66*, 488-491.

Brophy, J. (1983). *Classroom organization and management. In David C. Smith (Ed.), Essential knowledge for beginning teachers* (pp. 23-37). Washington, DC: American Association of Colleges for Teacher Education.

Brophy, J. (1982). Supplemental group management techniques. In Daniel Duke (Ed.), *Helping teachers manage classrooms* (pp. 33-51). Alexandria, VA: Association for Supervision and Curriculum Development.

Brophy, J, & Evertson, C. (1978). Context variables in teaching. *Educational Psychologist, 12*, 310-316.

Canter, L., & Canter, M. (1992). *Assertive discipline*. Santa Monica, CA: Lee Canter and Associates.

Canter, L. (1976). *Assertive discipline*. Los Angeles: Lee Canter & Associates.

Cotton, K. & Savard, W. (1982). Student discipline and motivation: Research synthesis. (Prepared for Northeast Regional Educational Laboratory, April, 1982). In Discipline. Bloomington, IN: Phi Delta Kappa.

Curwin, R. & Mendler, A. (1988). *Discipline with dignity*. Alexandria, VA: Association for Supervision and Curriculum Development.

DeBruyn, R. (1993). How to deal with violent students. *The Master Teacher, 24* (23).

Dobson, J. (1971). *Dare to discipline*. Wheaton, IL: Tyndale House.

Dreikurs, R. & Cassell, P. (1972). *Discipline without tears*. New York: Hawthorne Books.

Elam, S., Rose, L., & Gallup, A. (1994). The 26th annual Phi Delta Kappa/Gallup poll of the public's attitudes toward the public schools. *Kappan, 76*(1), 41-56.

Emmer, E., & Aussiker, A. (1989). School and classroom discipline programs: How well do they work? In O.C. Moses (Ed.), *Strategies to reduce student misbehavior* (pp. 239-252). Washington, DC: U.S. Department of Education.

Evertson, C. & Emmer, E. (1982). Preventive classroom management. In Daniel Duke, (Ed.) *Helping teachers manage classrooms* (pp. 2-31). Alexandria, VA: Association for Supervision and Curriculum Development.

Feitler, F., Weiner, W., & Blumberg, A. (1970). *The relationship between interpersonal relations, orientations, and preferred classroom Physical settings*. Paper presented at the American Educational Research Association Convention, Minneapolis, MN. (ERIC Document Reproduction Service No. ED 039 173).

Georgiady, N., Sinclair, R., & Sinclair, C. (1991). What is the most effective discipline? *Principal, 71*(1), 49-50.

Glasser, W. (1969). *Reality therapy*. New York: Harper & Row.

Gordon, T. (1974). *Teacher effectiveness training*. New York: Wyden.

Gotfredson, D. (1992). Discipline. In M.C. Alkin (Ed.), *Encyclopedia of educational research*. (6th ed.). New York: The Free Press.

Guay, D. (1993). *Routines and rules: Managing for accomplishment in the secondary art classroom*. Paper presented at the National Art Education Association Convention, Chicago, IL.

Hall, E. (1969). *The hidden dimensions*. New York: Anchor Books.

Henley, N. (1977). *Body politics*. Englewood Cliffs, NJ: Prentice-Hall.

Heyman, M. (1978). *Places and spaces: Environmental psychology in education*. Bloomington, IN: The Phi Delta Kappa. Educational Foundation.

Kindsvatter, R. (1979). Death, taxes—and discipline. *American Middle School Education, 2*(2), 11-21.

Kindsvatter, R., Wilen, W., & Ishler, M. (1988). *Dynamics of effective teaching*. White Plains, NY: Longman.

Kounin, J. (1970). *Discipline and Group management in classrooms*. New York: Holt, Rinehart and Winston.

Lasley, T. (1994). Teacher technicians: A "new" metaphor for new teachers. *Action in Teacher Education, 16*(1), 11-28.

Lasley, T. (1986). Classroom management: Perspectives for the preservice teacher. In R. Kindsvatter & S. McClain (Eds.), *Teaching about discipline in teacher education* (pp.13-24). Kent, OH: Ohio Association of Teacher Educators.

McDaniel, J. (1986). A primer on classroom discipline: Principles old and new. *Kappan, 68*(1), 63-67.

McLaughlin, H. (1994). From negation to negotiation: Moving away from the management metaphor. *Action in Teacher Education, 16*(1), 75-85.

Project TEACH. (1977). *Project TEACH*. Westwood, NJ: Performance Learning Systems. (ERIC Document Reproduction Service No. ED 167 527).

Randolph, C. & Evertson, C. (1994). Images of management for learner-centered classrooms. *Action in Teacher Education, 16*(1), 55-64.

Weinstein, C. (1981). Classroom design as an external condition for learning. *Educational Technology, 21*(8), 12-19.

Weinstein, C. (1979). The physical environment of the school: A review of the research. *Review of Educational Research, 49*, 577-610.

*Notes*